CW00455040

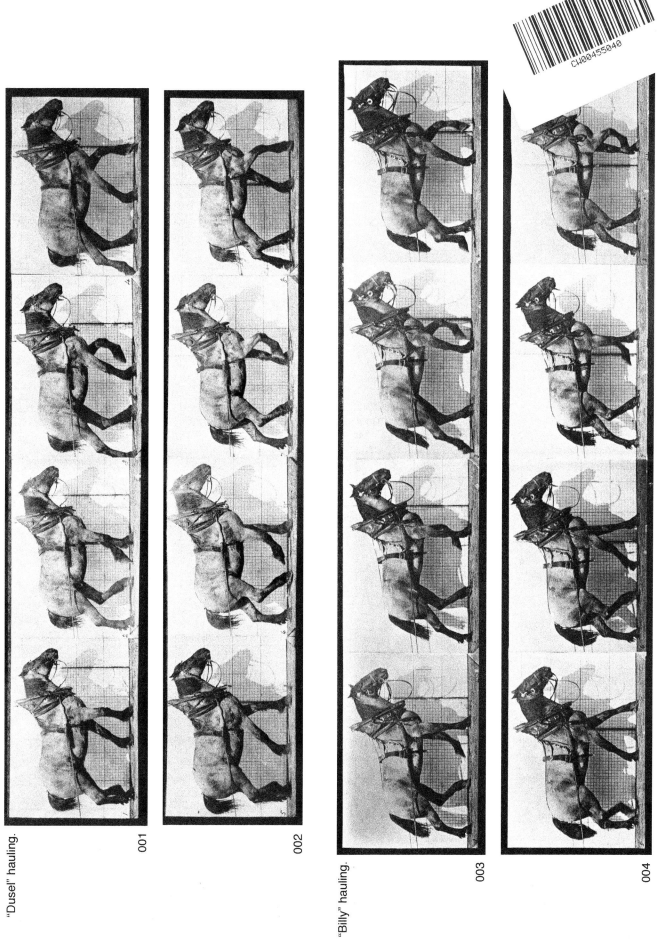

"Dusel" hauling.

001

002

"Billy" hauling.

003

004

1 HORSES

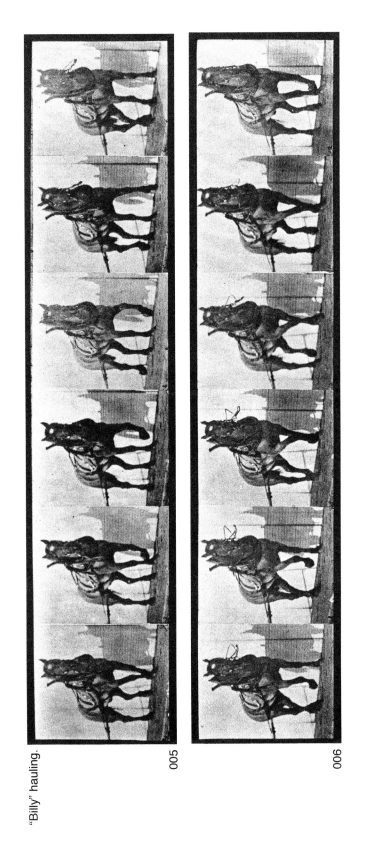

"Billy" hauling.

005

006

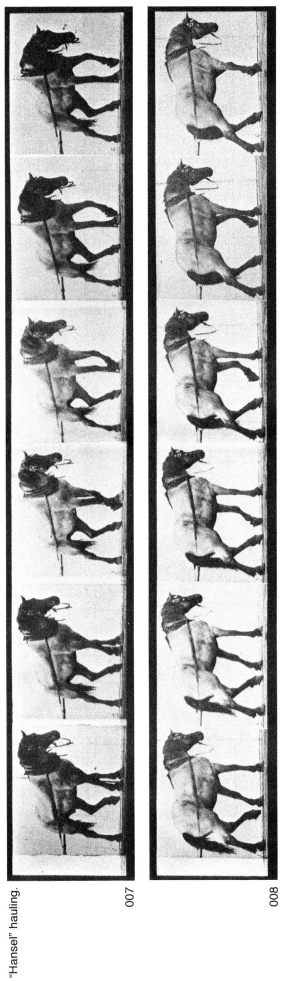

"Hansel" hauling.

007

008

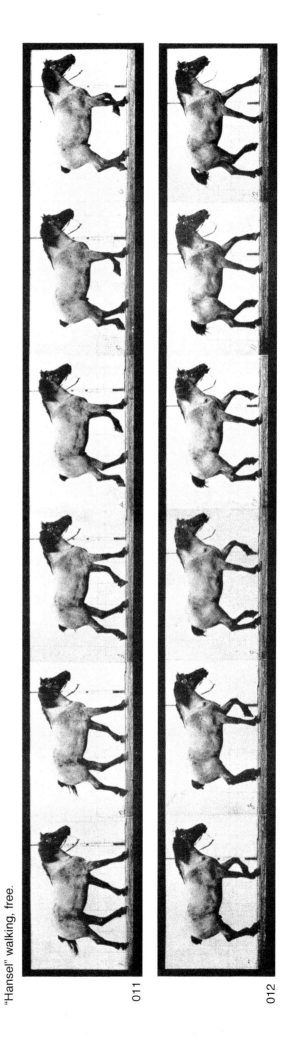

"Johnson" hauling, man pulling at head.

009

010

"Hansel" walking, free.

011

012

"Eagle" walking, free.

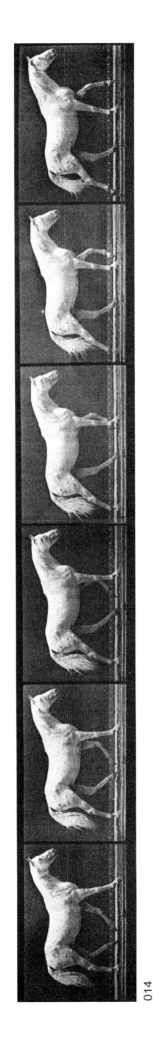

013

014

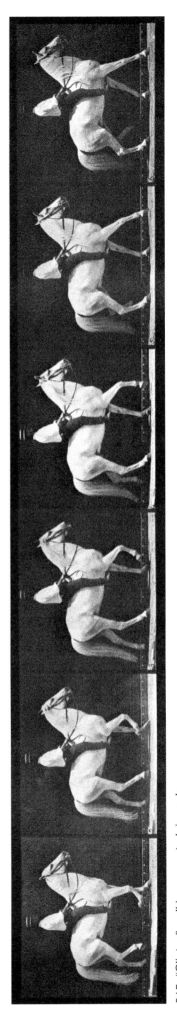

015 "Clinton" walking, mounted, irregular.

4 HORSES

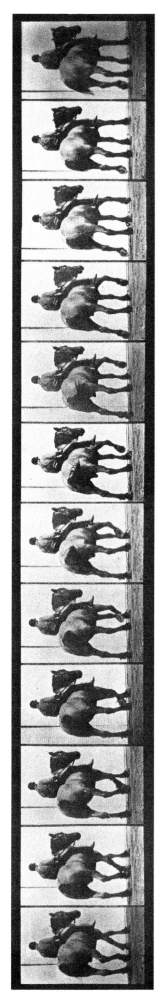

016 "Dusel" walking, bareback.

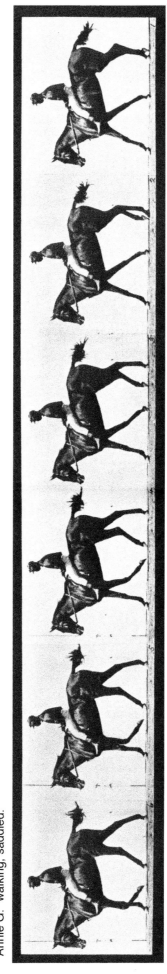

"Annie G." walking, saddled.

017

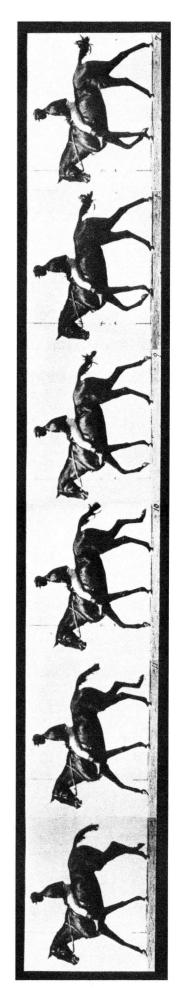

018

5 HORSES

"Smith" walking, bareback; rider nude.

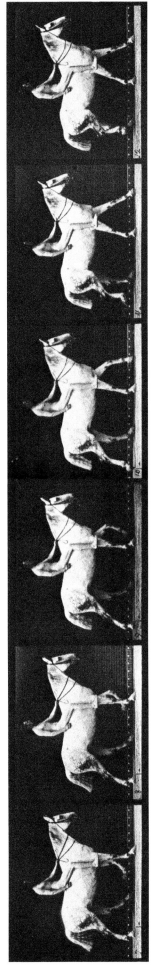

019

020

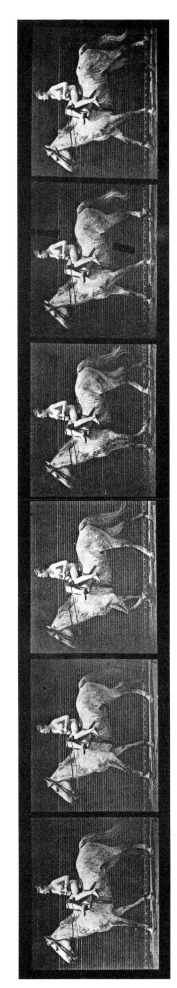

021 "Tom" walking, saddled; female rider nude.

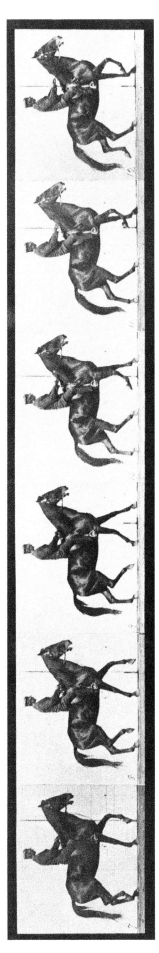

022 "Beauty" walking, saddled, irregular.

"Clinton" ambling, bareback; rider nude.

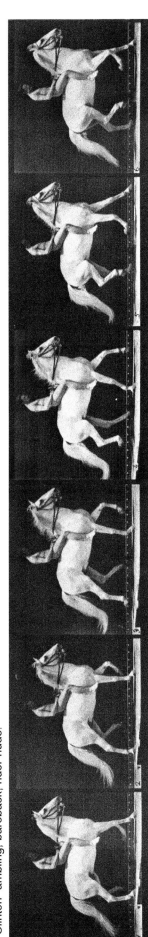

023

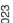

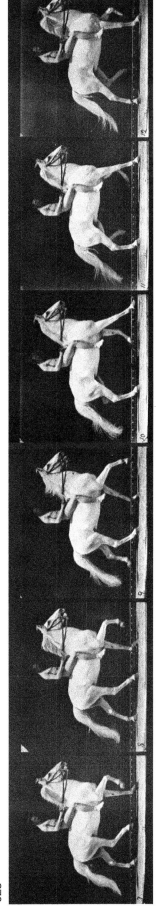

024

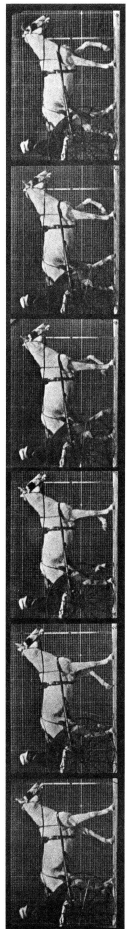

025 "Katydid" walking, harnessed to sulky.

7 HORSES

"Pronto" pacing, saddled.

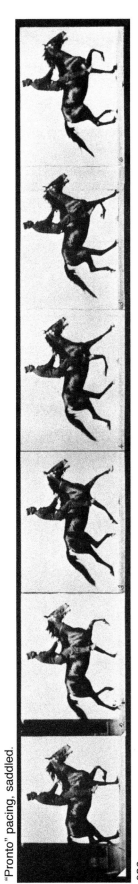

026

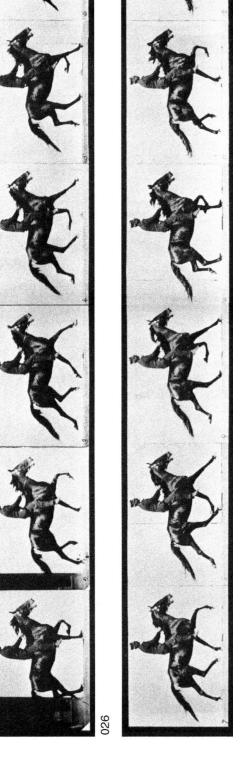

027

"Pronto" pacing, harnessed to sulky

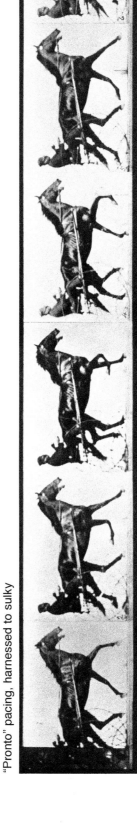

028

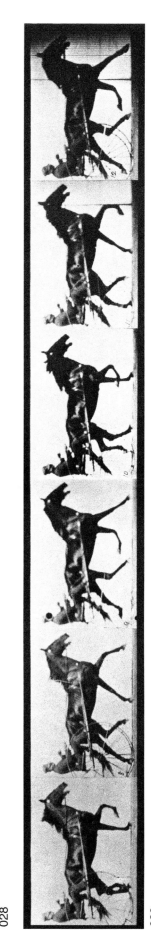

029

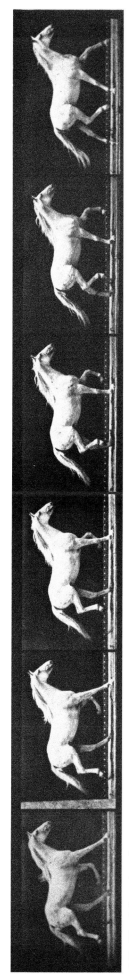

030 "Eagle" trotting, free.

"Daisy" trotting, saddled.

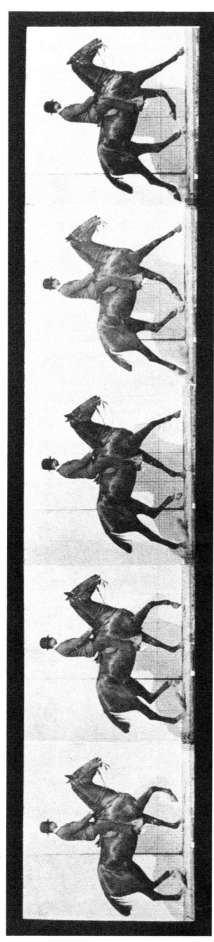

031

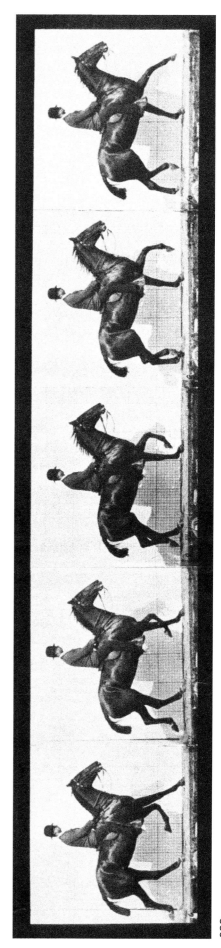

032

9 HORSES

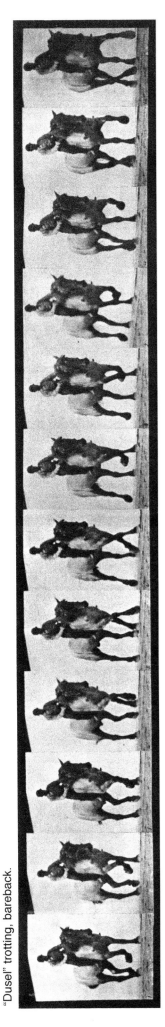

"Dusel" trotting, bareback.

033

034

"Beauty" trotting, saddled.

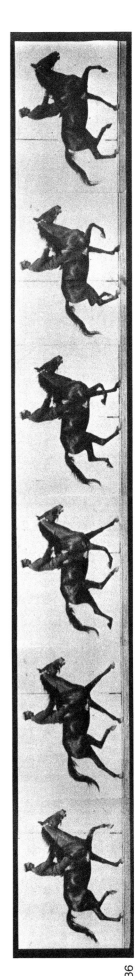

035

036

10 HORSES

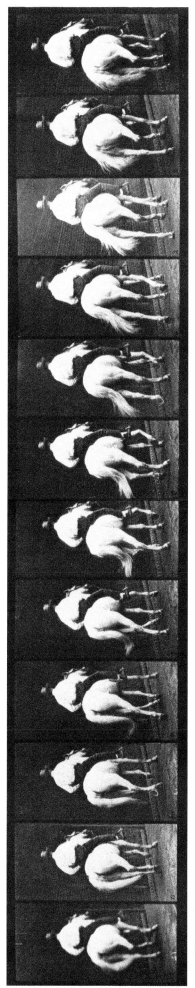

037 "Elberon" trotting, saddled.

"Reuben" trotting, harnessed to sulky.

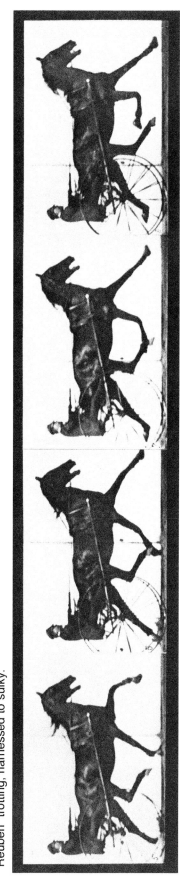

038

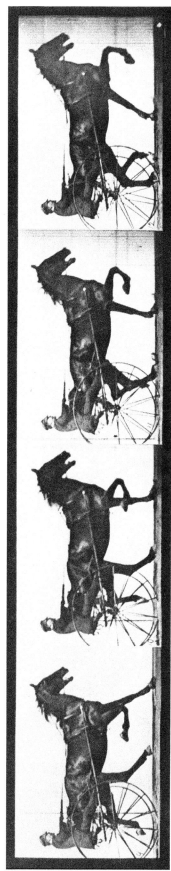

039

11 HORSES

"Katydid" trotting, harnessed to sulky.

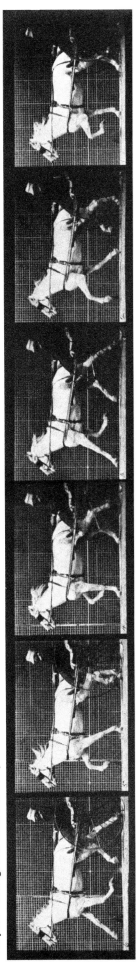

040

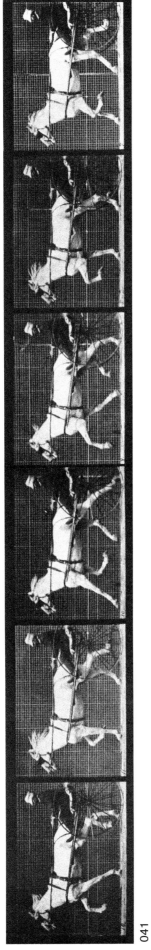

041

"Nellie Rose" trotting, harnessed to sulky.

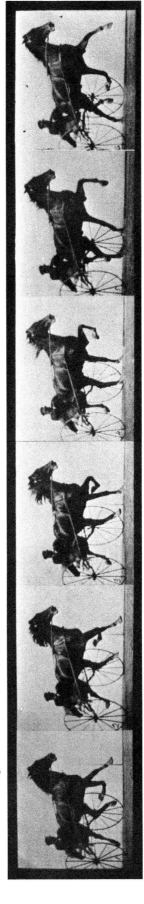

042

043

"Daisy" cantering, saddled.

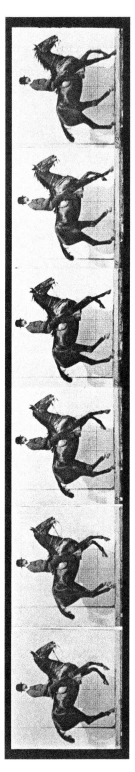

044

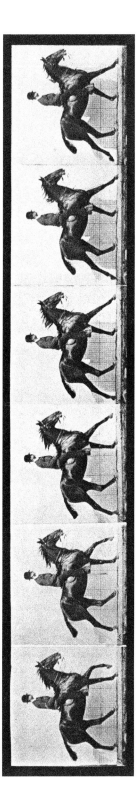

045

"Annie G." cantering, saddled.

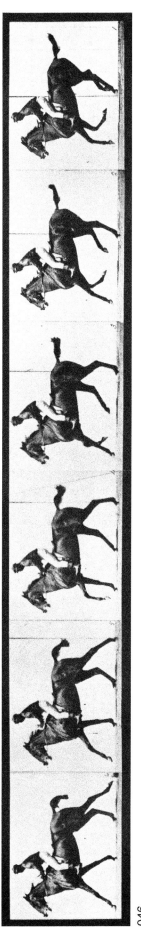

046

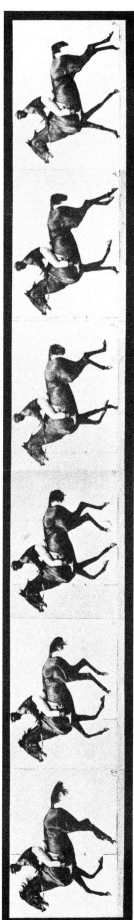

047

13 HORSES

"Daisy" galloping, saddled.

048

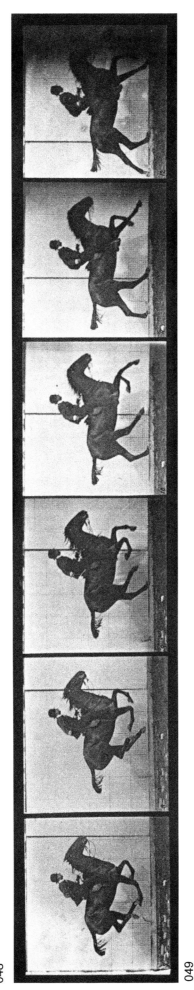

049

"Bouquet" galloping.

050

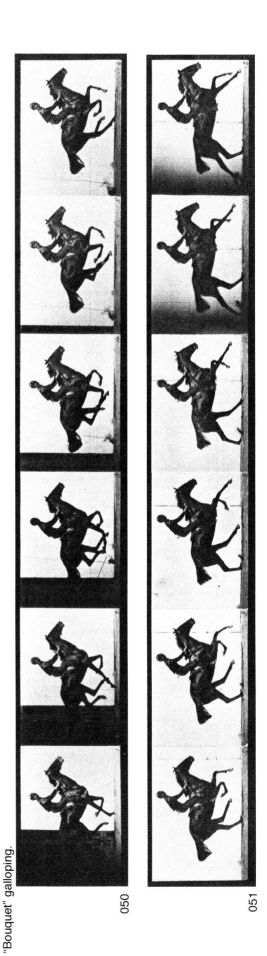

051

14 HORSES

"Hansel" galloping, bareback.

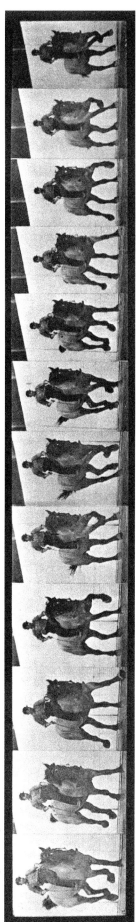

052

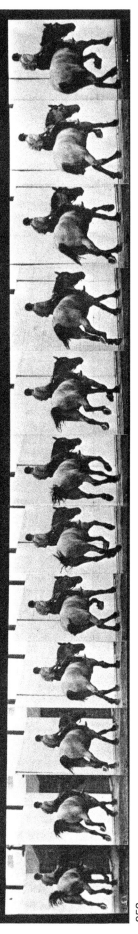

053

"Bouquet" galloping, saddled.

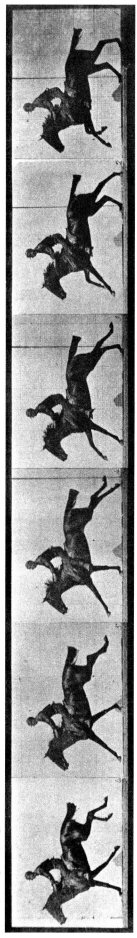

054

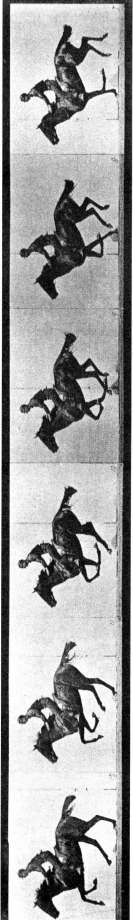

055

15 HORSES

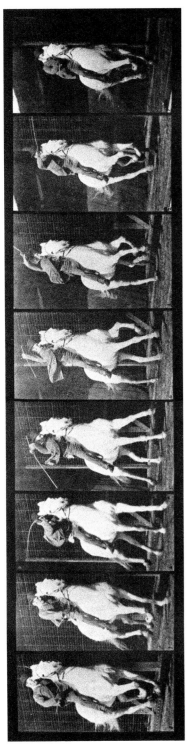

056 "Dan" galloping, saddled.

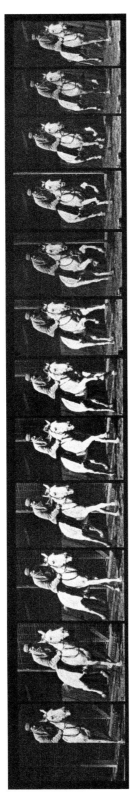

057 "Pandora" galloping, saddled.

"Daisy" jumping a hurdle, saddled, preparing for the leap.

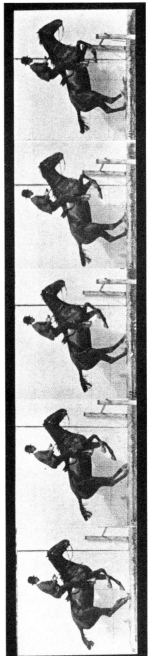

058

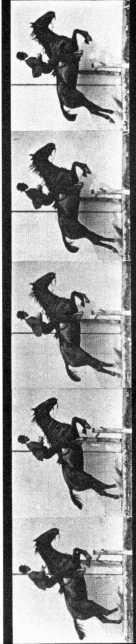

059

"Daisy" jumping a hurdle, saddled, clearing, landing, and recovering.

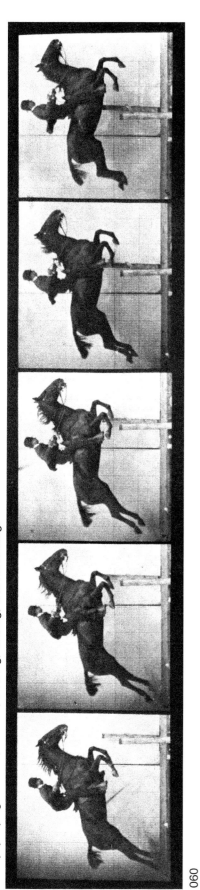

060

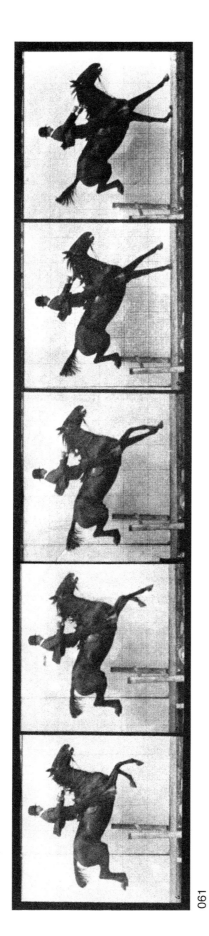

061

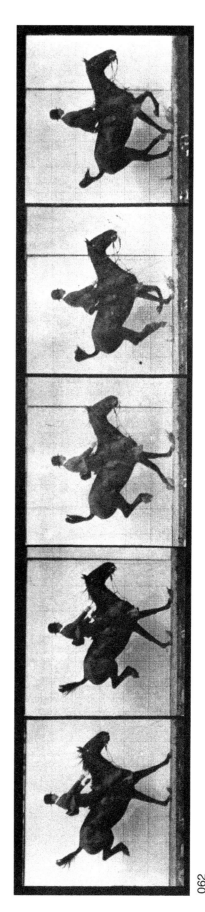

062

"Daisy" jumping a hurdle, saddled.

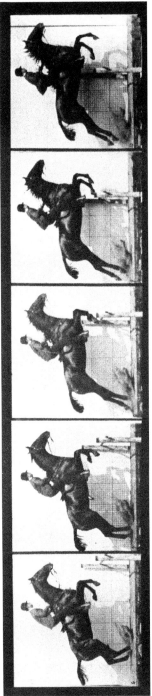

063

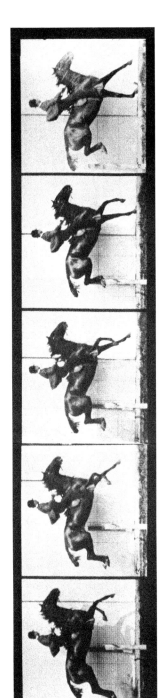

064

"Pandora" jumping a hurdle, bareback, clearing, and landing; rider nude.

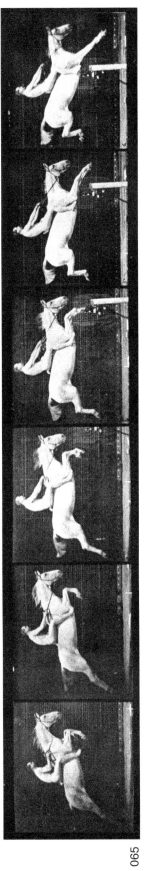

065

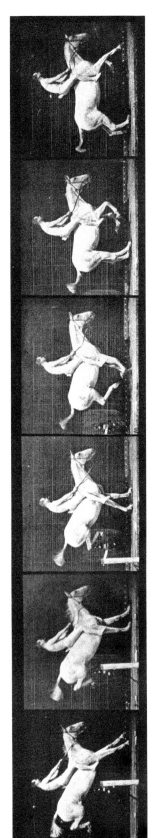

066

"Hornet" jumping over three horses.

067

068

069

070

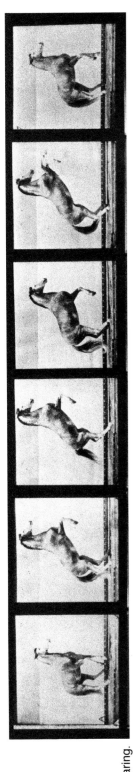

071 Horse rearing.

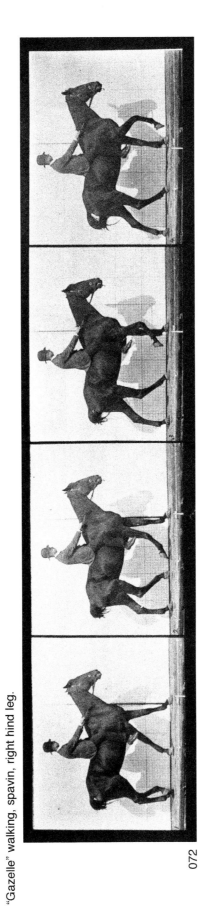

"Gazelle" walking, spavin, right hind leg.

072

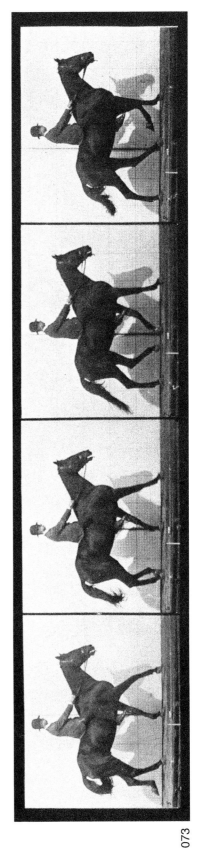

073

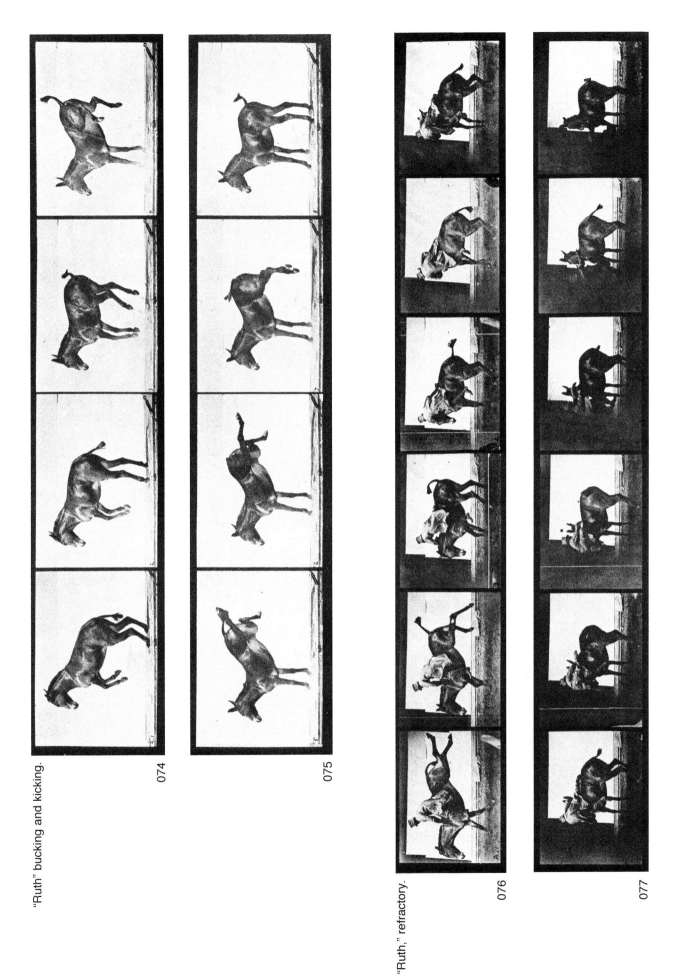

"Ruth" bucking and kicking.

074

075

"Ruth," refractory.

076

077

"Denver," refractory.

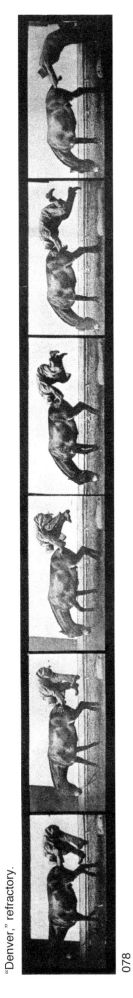

078

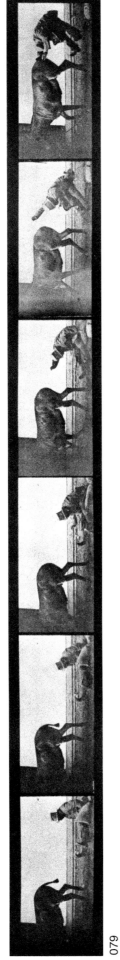

079

"Jennie" walking, bareback; a boy riding.

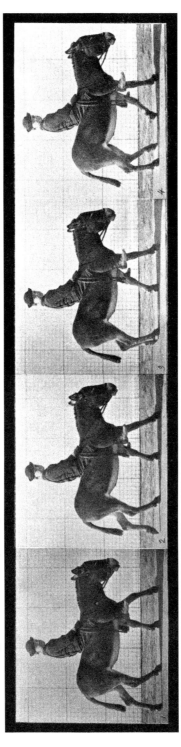

080

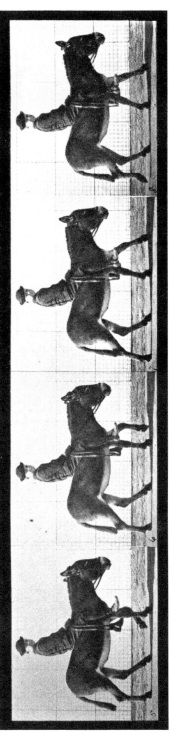

081

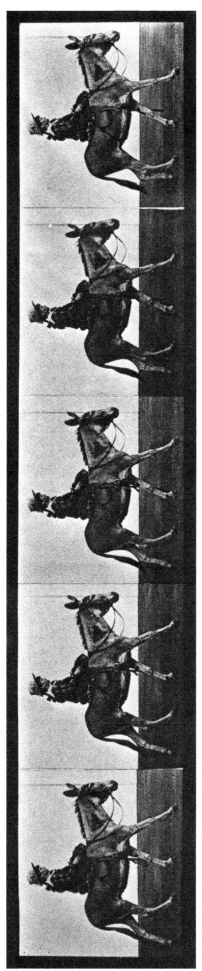

082 "Zoo" walking, saddled; a girl riding.

Sow walking.

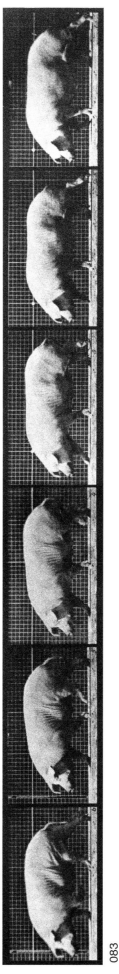

083

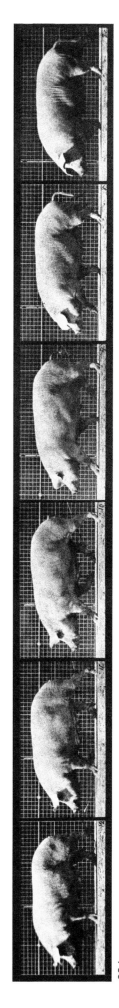

084

23 DOMESTIC ANIMALS

Ox walking.

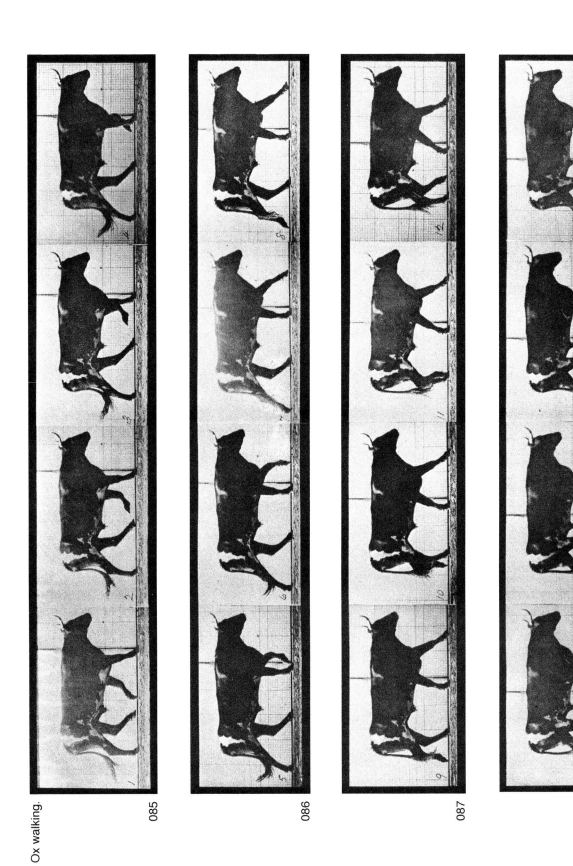

085

086

087

Goat walking.

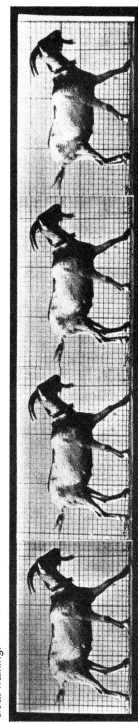

089

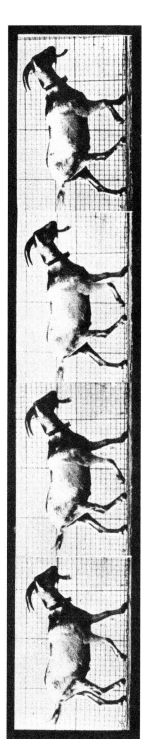

090

Goat trotting, harnessed to a sulky.

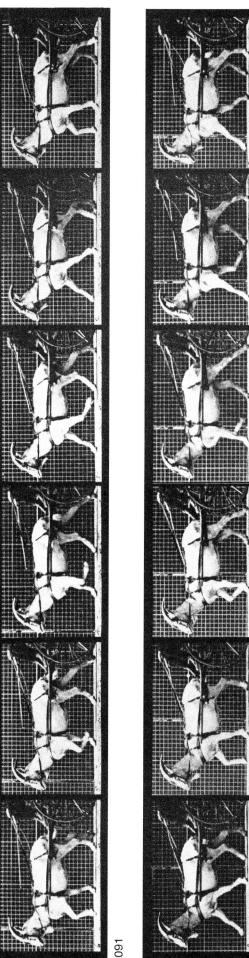

091

092

"Dread" walking, interrupted.

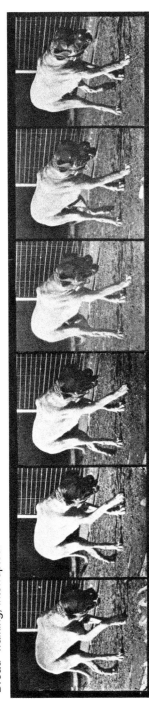

093

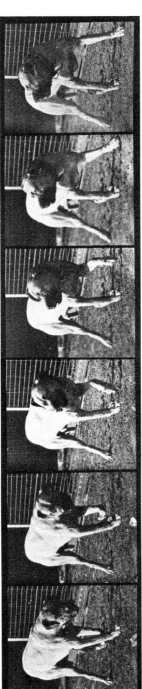

094

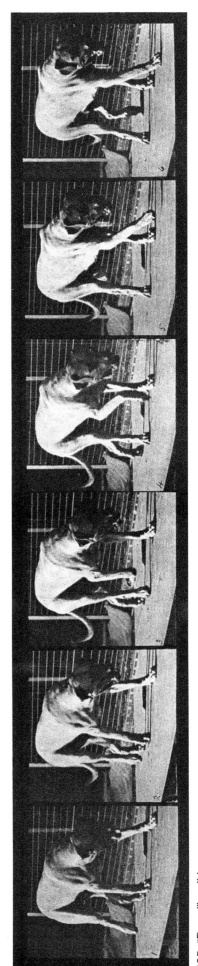

095 "Dread" walking.

"Dread" galloping.

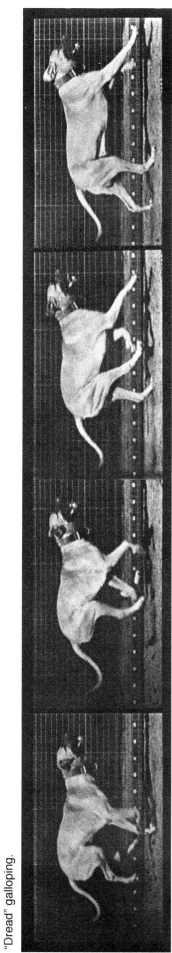

096

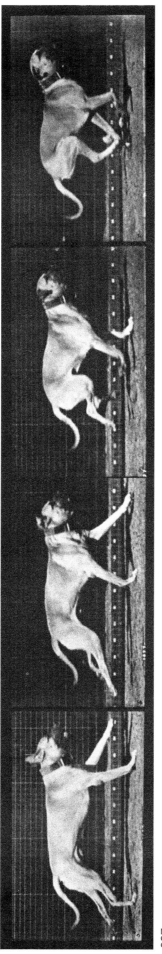

097

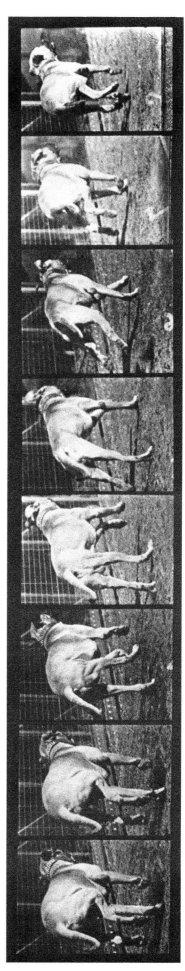

098

27 DOMESTIC ANIMALS

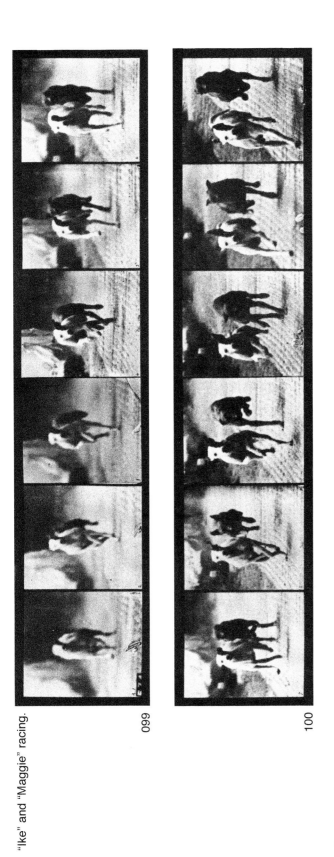

"Ike" and "Maggie" racing.

099

100

"Kate" turning around.

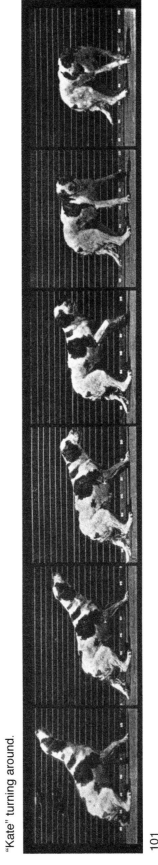

101

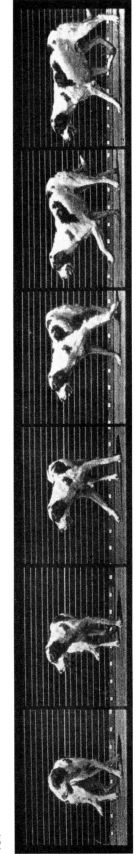

102

"Smith" aroused by a torpedo.

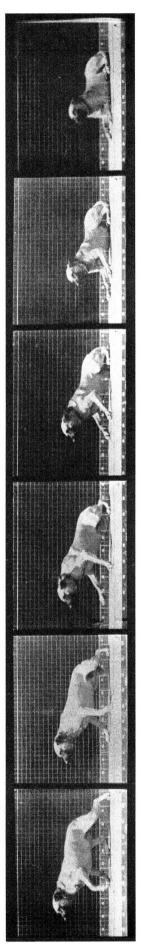

103

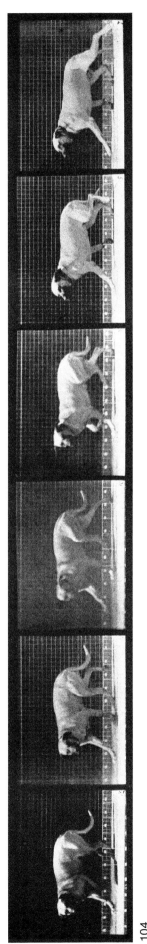

104

Cat galloping.

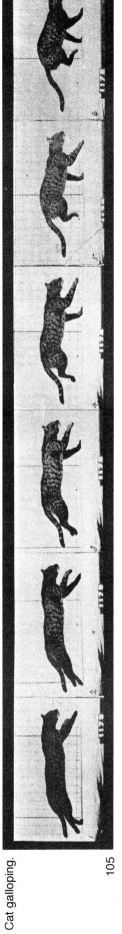

105

106

29 DOMESTIC ANIMALS

Cat trotting, changing to a gallop.

107

108

109

110

30 DOMESTIC ANIMALS

Fallow deer, buck, trotting.

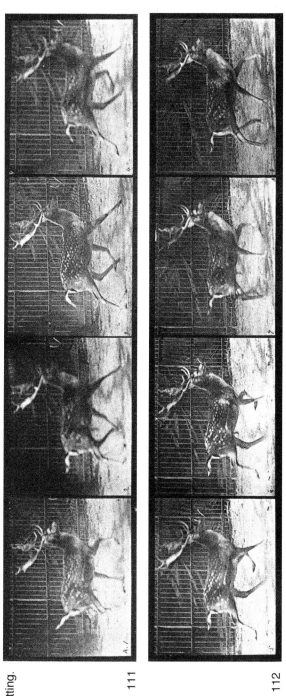

111

112

Fallow deer, buck and doe, galloping.

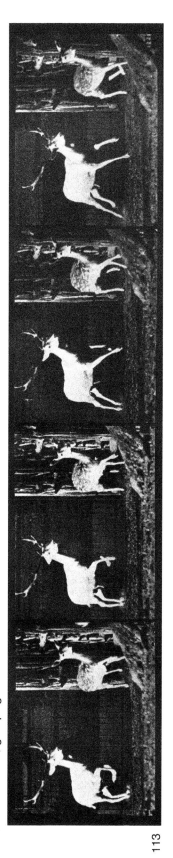

113

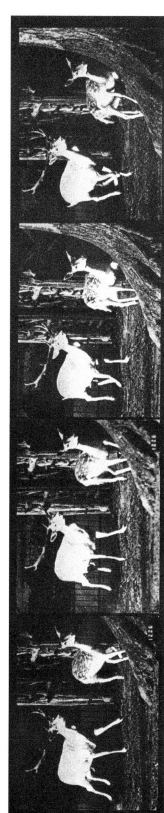

114

31 DOMESTIC ANIMALS

Fallow deer, doe galloping and kid jumping.

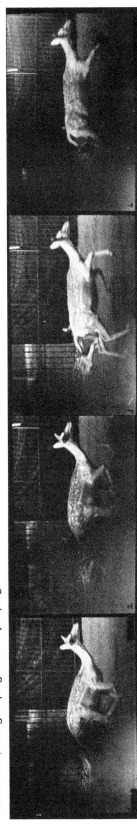

115

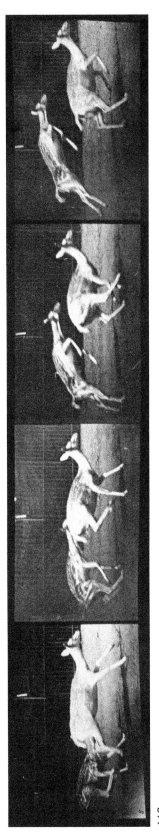

116

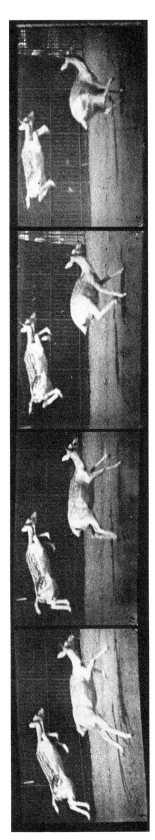

117

Elk trotting.

118

119

Elk galloping.

120

121

Buffalo galloping.

122

123

124

125

Lion walking.

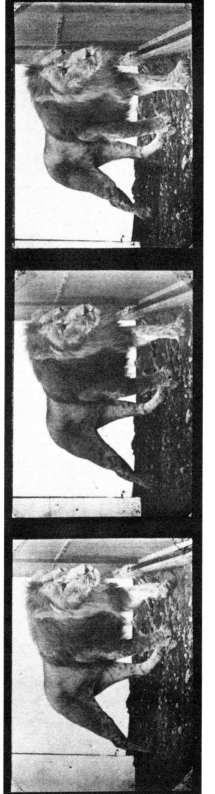

126

127

128

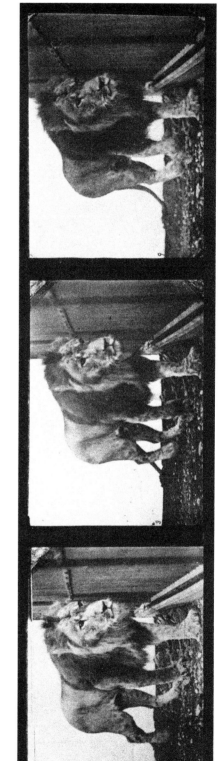

Lion walking and turning around.

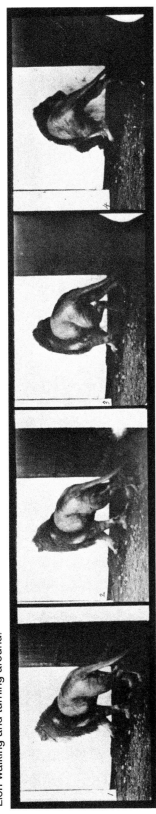

129

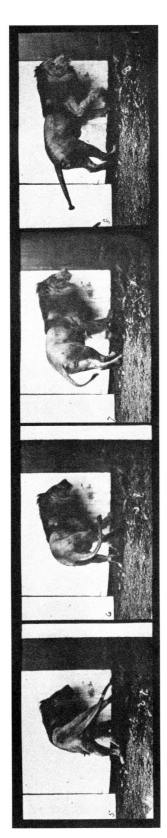

130

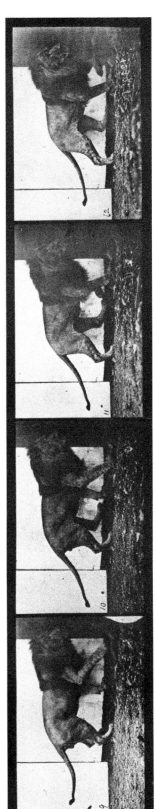

131

Tigress walking.

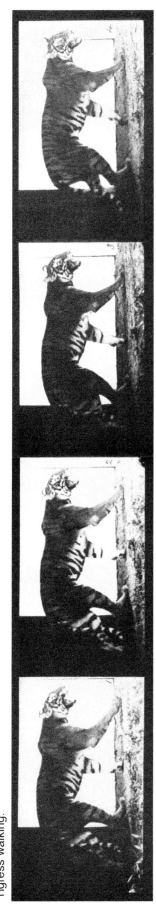

132

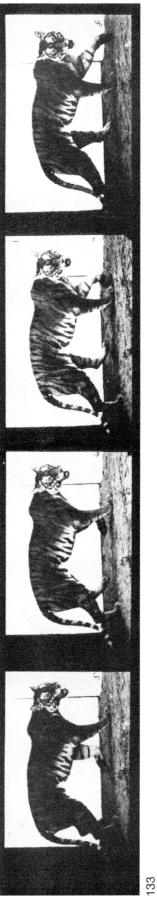

133

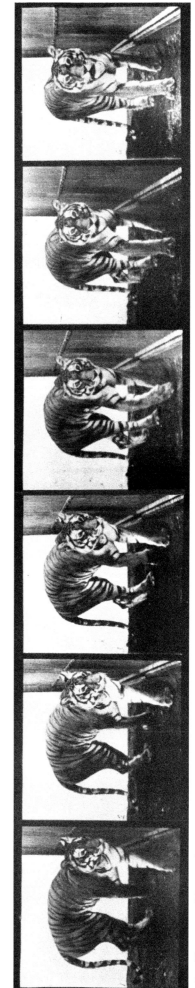

134 Tigress walking and turning around.

Elephant walking.

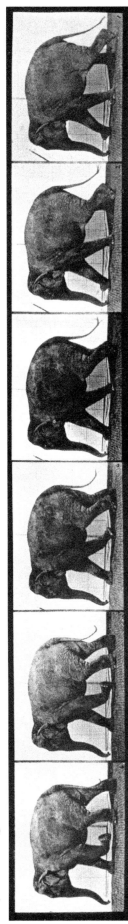

135

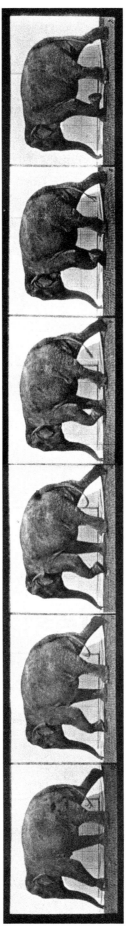

136

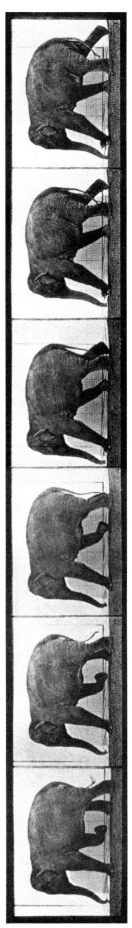

137

Two elephants walking.

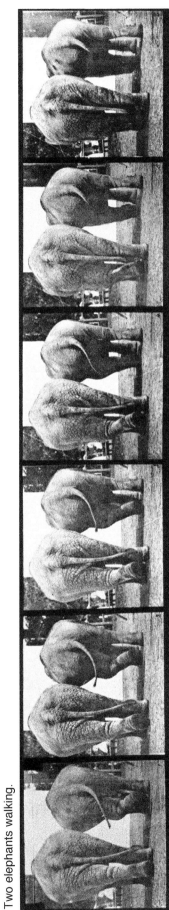

138

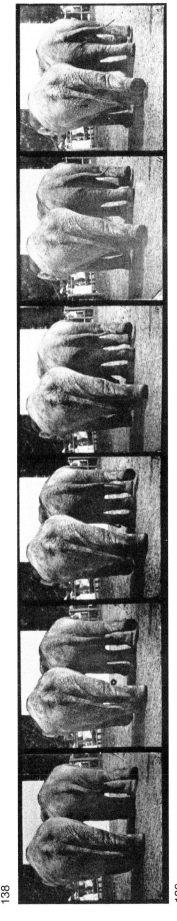

139

Egyptian camel racking.

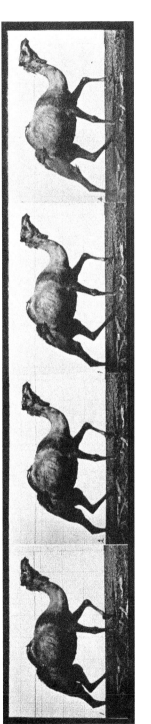

140

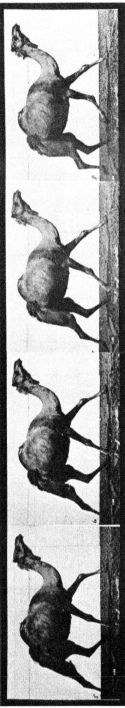

141

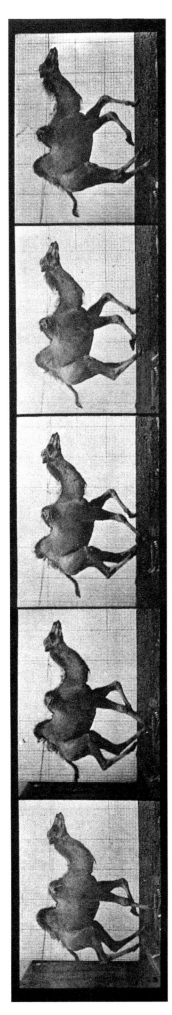

142 Bactrian camel galloping.

Raccoon walking, changing to a gallop.

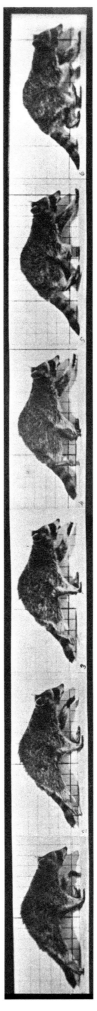

143

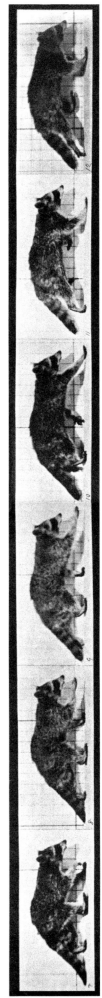

144

Baboon walking on all fours.

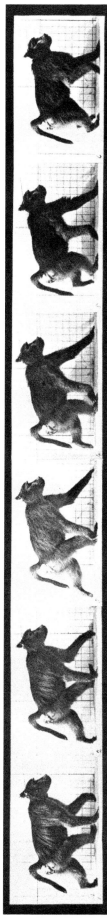

145

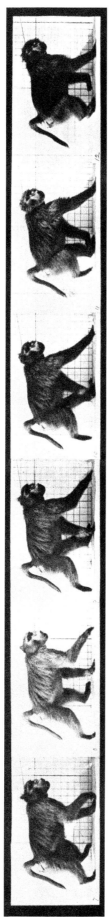

146

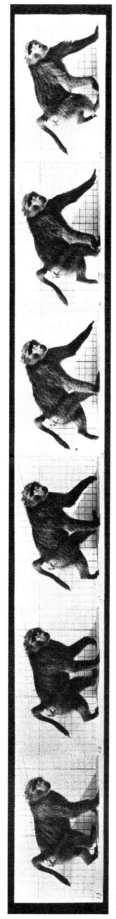

147

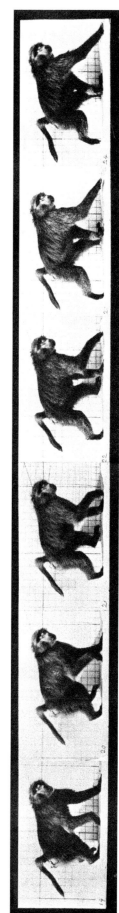

148

Sloth walking suspended on a horizontal pole.

149

150

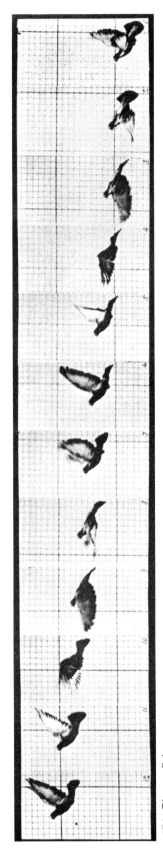

151 Pigeon flying.

Cockatoo flying.

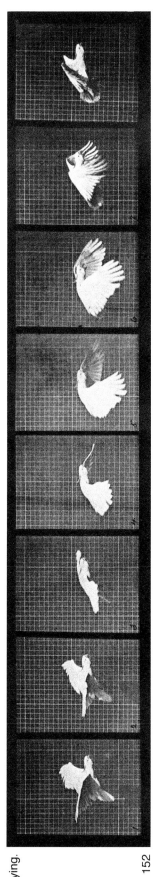

152

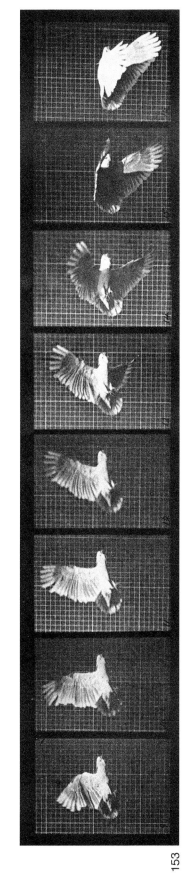

153

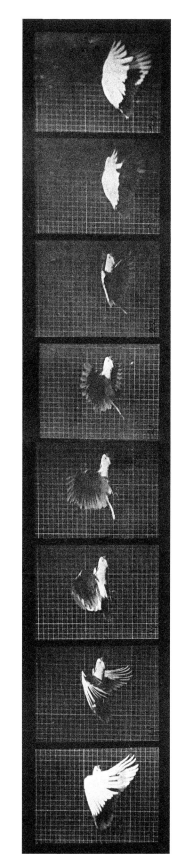

154

43 WILD ANIMALS & BIRDS

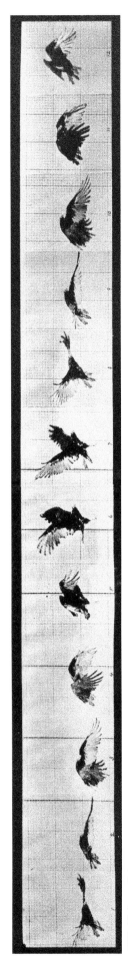

155 Vulture flying.

Cockatoo flying.

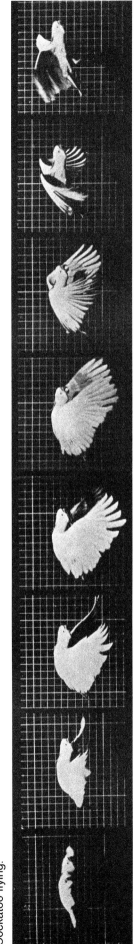

156

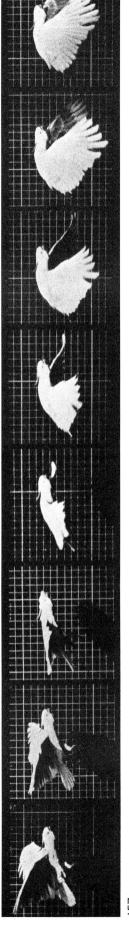

157

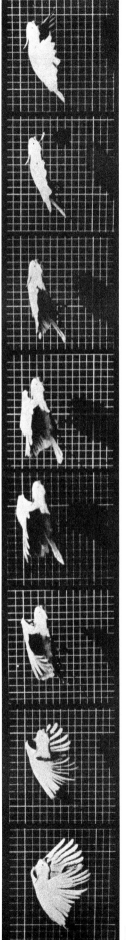

158

44 Wild Animals & Birds

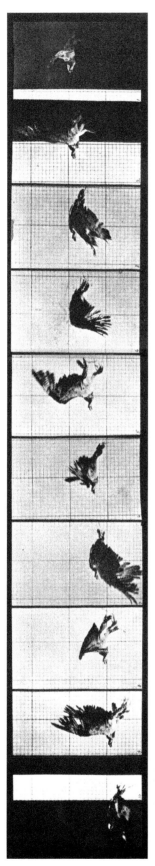

159 Fish hawk flying

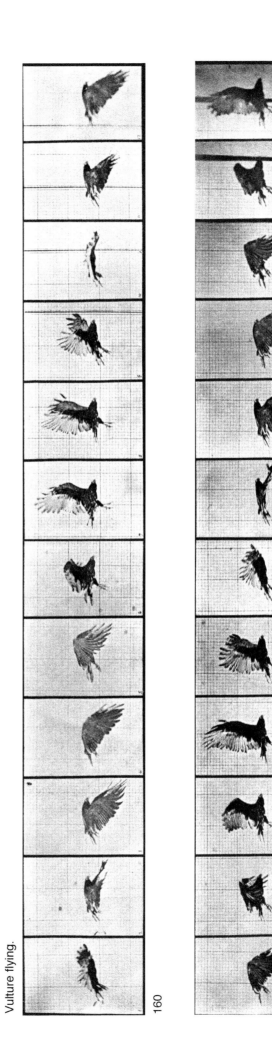

Vulture flying.

160

161

Ostrich running.

162

163

164 American eagle flying.

46 WILD ANIMALS & BIRDS

American eagle flying near the ground.

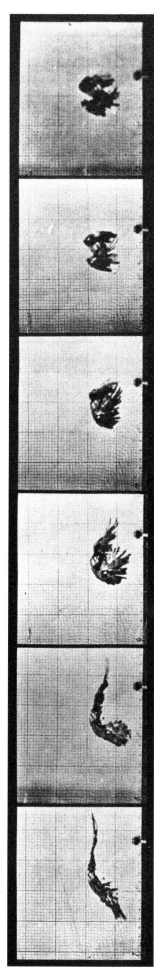

165

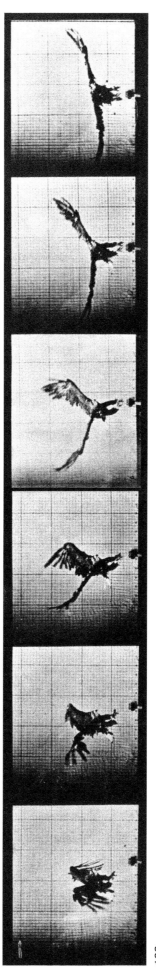

166

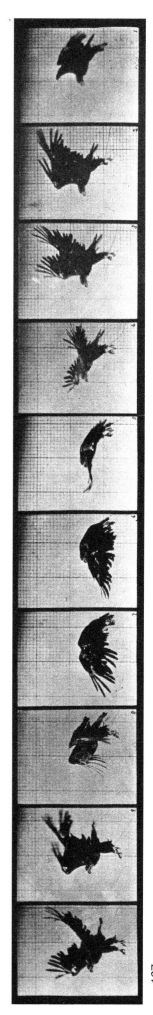

167

47 WILD ANIMALS & BIRDS